CHARLES MATTON

CHARLES MATTON

Within These Walls

Forum Gallery

NEW YORK

Published on the occasion of the exhibition at
Forum Gallery in New York City, May 16 — June 21, 2002

Published by Forum Gallery

Designed and Produced by Impress, Inc., Northampton, MA
Katie Craig, Book Designer
Hans Teensma, Creative Director
Color photography by Yann Matton

Printed in China

Library of Congress Cataloging-in-Publication Data is available on request.
ISBN 0-9675826-4-4

First Edition

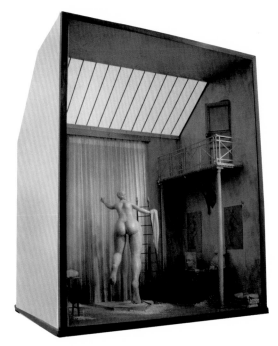

FIG 1

Holding details in high esteem.
Looking for the truth in what appears,
not what is behind appearances.

—ALAIN FINKIELKRAUT

L'Imparfait du Presént

CHARLES MATTON
METICULOUS ILLUSIONIST

'What a curious feeling!' said Alice; 'I must be shutting up like a telescope.'

A DIVINE BEAUTY

In his canonical description of Renaissance art, Vasari divides the Renaissance into three discrete periods corresponding roughly to: the Pre-Renaissance, the Early Renaissance and the High Renaissance or Mannerist period. It is this third—Vasari's "Eta Moderna"—that offers such a compelling connection to the work of Charles Matton, the polymath artist who lives and works in Paris.

For Vasari, the High Renaissance concept of grazia (roughly "gracefulness") referred both to divine grace and also to the concept of an ideal beauty reflected in the art of this period (most notably Michelangelo, Leonardo and Raphael). Although it was never specifically defined, grazia in the context of art is a balance between mastery and self-effacing naturalness. It is

this interpretation of the term that is so readily apparent in the virtuosity of Matton's current oeuvre: the creation of boxes—vignettes that reflect Matton's deep fascination with a vast variety of intellectual endeavors, from the work of old and modern master artists, to philosophers and other purveyors of significant thought. Matton's objects create an unselfconscious ideal in the form of a meticulously crafted (and irresistible) artificial environment—one that engages the aesthetic and stimulates the intellect.

Matton's objects captivate the viewer and reveal the essential nature of places, even as they question our perception of space, light and time. Invited into his world, we are simultaneously seduced into a deeper connection to our own constructed worlds.

. . .

CREATION

Each box is a self-contained universe, a miniaturized space in three dimensions. To create his environments, his conception is developed in life- or larger-than-life-size, through draftsmanship or painting, and then refined and distilled to its miniaturized form. Every single element in a box is re-

sculpted in minute form, re-cast and painted and built into the box. Every element of the construction is intricately modeled by his hand.

Through this process of miniaturization and reconfiguration, the box eventually begins to take shape as its various elements are added to the complex composition. Executed with such precision, the resulting artwork challenges the viewer to unravel the multi-faceted images and stretch their realm of understanding. Matton does more than merely translate an existing or imagined quotidian space into a reduced scale. Rather, the spaces seem to take on a new majesty through their exquisite detailing.

There is an antecedent to this tradition in the 17th-century Dutch perspective boxes. Produced in Holland in the middle of that century, these boxes employed linear perspective to create a three-dimensional space in miniature. Artists such as Samuel van Hoogstraten (1627-78) and others created boxes dealing with characteristic themes of the period including genre scenes and architectural views. Matton has created contemporary versions of this rare and almost forgotten art form that carry a similar intellectual challenge and whimsy.

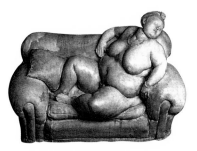

FIG 2

LIGHT

The use of light to direct the viewer is an essential tool for Matton, as it was for the Dutch 17th-century perspective box creators. In *The Shadow of the Painter*, the subtlety of the light is the defining element of the work. It is a simple interior, which includes an easel and several modeling stands with the painter's tools, and a screen that obscures part of the interior. Although there is no figure in the construction, there is a strong feeling of human presence in the studio. However, when the box is illuminated, a shadow of a painter is visible on one wall and a window is visible on

the adjacent wall. Matton has analyzed the environment and provided the viewer with the missing element. The challenge for the viewer is to place the painter in the room based upon how his shadow is illuminated. Only after some time does one seek to understand how the artist achieved the illusion.

Another work that uses the subtlety of light to capture essential meaning is *New York City Loft—Homage to Edward Hopper*. Matton shows his respect for the American master by capturing his even, pearly and eerie light that enhances the feeling of loneliness and isolation.

REFLECTION

Mirrors and windows accentuate the illusions of space and spatial inconsistencies. Also as symbols of vanity or self-reflection, they are powerful tools in Matton's boxes. The use of mirrors, reflecting or one-way, and false windows guide the viewer to cross the "picture plane" and become part of the construction. *The New York University Club Library*, for example, is equipped with reflecting mirrors in the construction creating a feeling of endless stacks, shelved with books in a rarified and peaceful environment.

The use of light from above gives the illusion of added height to the room. It is the play of spatial depth that is the conundrum for the viewer and stimulates the transition from objectively looking at these constructions to being subjectively absorbed by them.

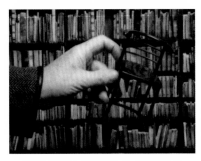

FIG 3

TEXTURE AND SCALE

All of the elements in the boxes are formed of epoxy resin, and every minute object is then molded and cast using high contents of marble powder. These objects are then painted, or patinated, to take on the form of gold frames, tubes of paint, parquet floors, brick walls, or as in *Library–Homage to Marcel Proust*, marble overmantels, ashtrays, celadon vases and books. These elements are so precisely created to give us a window to Charles Matton's intellect and his humanistic view of the world. In a letter to the Spanish painter Antonio Lopez Garcia, Matton states what he admires about the work of Lopez Garcia and where the two artists stand

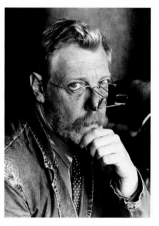

FIG 4

on the same solid ground. "The task of 'revealing' even the tiniest object in such a way demands meticulous care, the life-respecting precision of a surgeon, since the smallest error, the slightest lapse of attention would be fatal to the exercise. I think the process demands a great deal of love, and a very high degree of modesty."

The masterpiece of texture and scale in this exhibition is *Sigmund Freud's Study*. A photograph of Freud in his Viennese study provided the inspiration for this construction. A chair of tufted leather, a wood desk and — most importantly — Freud's collection of small ancient sculpture in stone and bronze and books abundantly surround the doctor's desk. The creation of this miniaturized space provides inspiration and reflection for Matton as we can imagine that it did for Freud. At the same time, Freud's own magnificent collection serves as the perfect muse for Matton's virtuosity.

ESPRIT DE FORME

When looking at the work of Charles Matton, one can see his fascination with form and a consistency in level of form development in painting, drawing and sculpture. This is particularly exceptional since Matton is a self-trained artist who was prevented from studying in the French art schools during the 1950's, when they were aggressively discriminatory towards representation.

Perhaps because he executes all the work himself in every medium, the objects carry his own special signature. Matton calls this an "esprit de forme"—spirit of form. Such a spirit can be seen in the *Rhinoceros—Homage to Eugene Ionesco*, an animal that in its reality has the form sense that matches Matton's and has served as his inspiration. In the box, akin to a 19th-century Wundercabinet, where the rhinoceros is studied and appreciated, the walls are filled with drawings and photographs of a rhino sculpture that Matton made in monumental form. This construction is a sort of trophy and memorial to this previous work, reflected infinitely through the mirrored composition.

CONTENT THEMES

Homages, Studios and Human Spaces: Three categories of constructions are present in the work of Matton. The homage is a recurring thematic subject, and represents the remarkable admiration the artist holds for thinkers, artists and writers. *Sigmund Freud's Study* fits neatly into this category. In addition, *New York City Loft—Homage to Edward Hopper* shows Matton's appreciation of the American artist's ability to create atmosphere and emotional intensity.

The second category is the studio interior. With natural modesty, Matton does not miniaturize his own atelier but actually creates a bridge to his homage category. *Saskia Awaiting Titus*, a representation of a sculptor's studio with a sculpture in process, gives insight into the studio interior. That the sculpture in process is a pregnant woman emphasizes the concept of studio as fertile "idea laboratory." Also, paying homage to Rembrandt, an old master who has profoundly influenced Matton, and who was the subject of an extremely well received 1999 film by Matton, this work has the lighting effects of a skylight studio. *The Big Storage Room*, although not actually an atelier, is a repository of images with a remarkable sense of space and light. One yearns to see what is beyond the corridor.

The last subject category is that of quiet interior places that emanate a human presence. *Yverdon Hotel, Genoa, Italy* portrays a grand hotel in the process of being renovated. Matton creates tension and verisimilitude through a sense of interrupted activity, coupled with an expectation that the workman will emerge from an unseen space. *The Apartment of Blvd. Saint Germain* is one of the most complicated and challenging constructions to grasp. The large scale painting and its miniature scale box depicts a gorgeous French interior with

FIG 5

three doors ajar allowing for glimpses to other doors and halls that presumably lead to more rooms. The viewer is stimulated to make spatial floor plans in their minds to figure out the construction, sparking and stimulating our own imaginations.

It is in the *Bedroom of a Collector* that the feeling of human presence is at its most palpable. Included among the striking details is the impression of the collector's body in the seat cushions: indicating that he or she has just

left the room. This subtle and masterful detail enhances the feel of immediacy and, in a sense, this box is the opposite of what the artist did in *The Shadow of the Painter*, in which he adds the missing human element. Here he takes out the obvious element, a figure, but adds the sense of a portrait of a personality.

■ ■ ■

One of the most remarkable things about Matton's works is the somatic and intellectual response the viewer experiences. Although we have seen that there is a considerable artistic tradition that serves as precedent for the creation of these boxes, one other compelling source — a hallmark of imagination — also exists. No modern viewer can look at Matton's miniaturized world without thinking of Lewis Carroll's Alice, after sipping the bottle marked "Drink Me":

> *'And so it was indeed: she was now only ten inches high, and her face brightened up at the thought that she was now the right size for going through the little door into that lovely garden.'*

As Matton's viewers, we are all Alices, desiring to shrink down and stand in his magnificent interiors replete with sculpture, lavish décor and a compelling narrative. Matton's surreal boxes give us the illusion that things that are possible are not, and what appears unreal is actually real.

—BARBARA S. KRULIK

"Meticulous Illusionist" is a quote from an article written by Charles Matton's friend and postmodern thinker, Jean Baudrillard, in the monograph published in 1991 on the artist.

Barbara S. Krulik is a writer and independent curator living in Amsterdam. She is the former Director of the New York Academy of Art's Graduate School of Painting and Sculpture. She also served as the Deputy Director of the National Academy Museum and School of Fine Arts in New York.

Sincerest thanks to Charles and Sylvie Matton for their gracious hospitality one rainy and magical afternoon in Paris; to Bob and Cheryl Fishko of Forum Gallery, New York and Los Angeles who continue to provide me with opportunities to engage with the compelling artists they represent; to John Dobler for a quick translation; and to my friend and editor, John M. Schobel, for his commitment to refining my ideas and polishing my words.

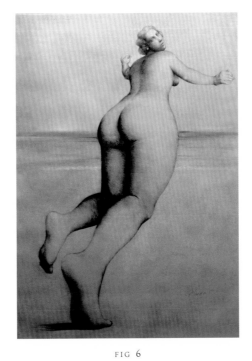

FIG 6

THE SHADOW OF THE PAINTER

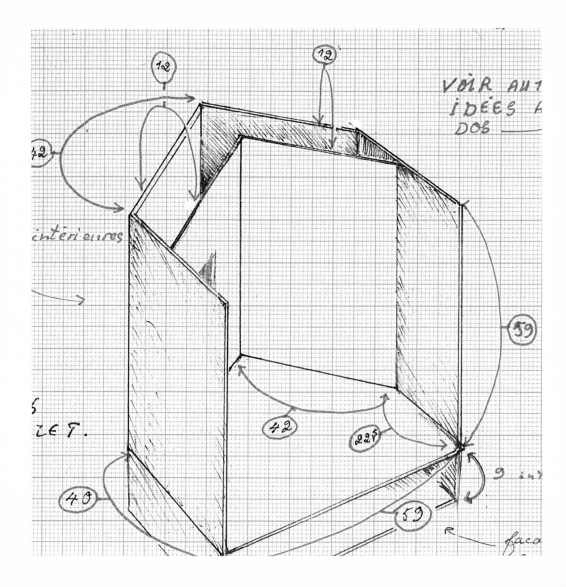

VÖIR AUT
IDEES A
DOB

intérieures

12

12

72

59

59

42

22,5

40

9 int

S
LE T.

R
faco

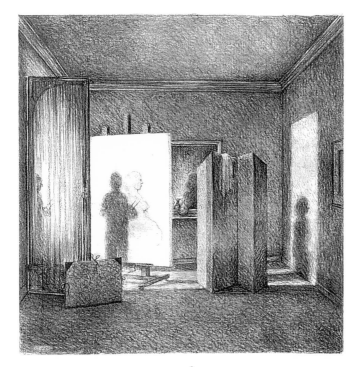

FIG 8

FIG 7

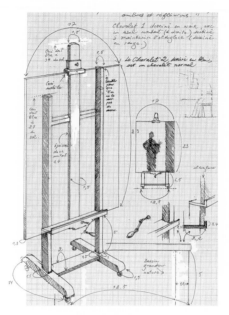

FIG 9

FIG 10

Au mur de fond à droite
trace au mur ou (au et)
dessins.

système pour
n'éclairer que
le dos de la
toile.

← luminaire

le modèle
de dos

luminaire

chevalet
de face

12

12

The Shadow of the Painter, 2002

23 7/8 x 28 3/8 x 28 inches

Mixed Media Construction

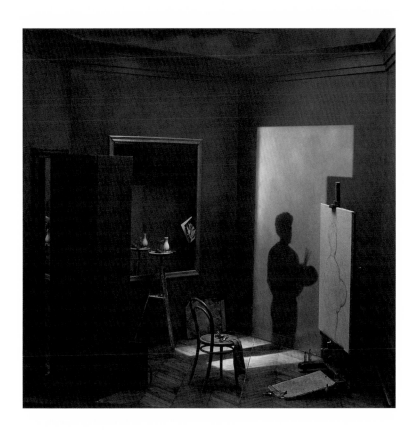

THE APARTMENT

■

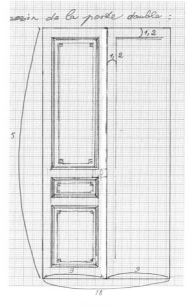

...ssin de la porte double :

1, 2

1, 2

5

9

9

18

FIG 11

FIG 12

11 Appartement 181 Boulevard Saint Germain
dans le 7ème arrondissement de Paris

(50)

miroir →

tenu ou quart de fauteuil club →

Toit amovible.

échelle : 7,72

façade C.

Si cette porte est grande ouverte, on peut envisager une fenêtre arrondie avec rideaux de tulle ici autre échelle

5

← miroir

Façade D.

3

A façade

façade B

60

Façade A et B. ↓

Façade C ↓

7

The Apartment of Blvd. Saint Germain, 2002

20 3/8 x 24 3/8 x 18 3/4 inches

Mixed Media Construction

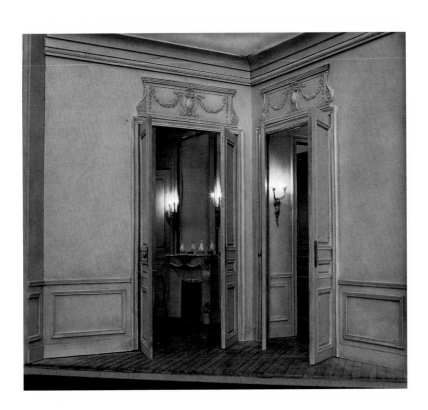

THE NEW YORK

UNIVERSITY CLUB LIBRARY

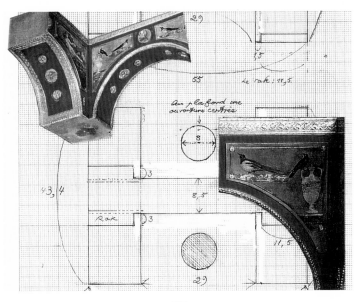

FIG 14

FIG 13

The New York University Club Library, 2002

23 1/8 x 18 5/8 x 38 5/8 inches

Mixed Media Construction

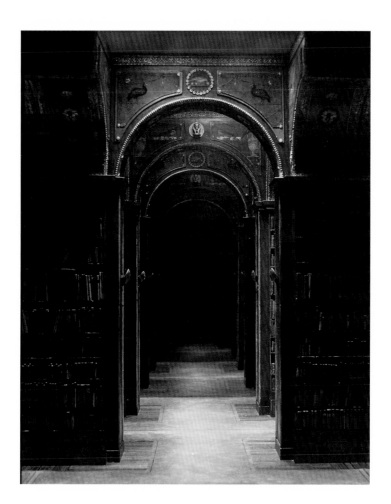

RHINOCEROS

Le Rhinocéros achevé.
– le mémorial.
– la corne de Cady.
– la double corne à achever.
– le jouet à rebricoler.
– les dessins d'Evry et du
 Coudray – Montceaux.
– les dessins du crâne d'éléphant
 et de bambous.
– Urbain.
– Photographies diverses dont
 ~~toutes~~ Sylvie et moi auprès
 du Rhinocéros surdimensionné.
– Moi avec la corne sur le nez.
– Le Rhinocéros sous la neige.
– le clin de l'Infante même!
– Reproduction miniaturisée
 du livre "Rhinocéros", page 17
 ou 21, 35 ? (53 le marqué),
 56 haut, 116.

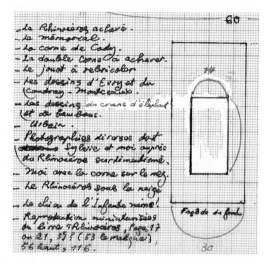

FIG 15

FIG 16

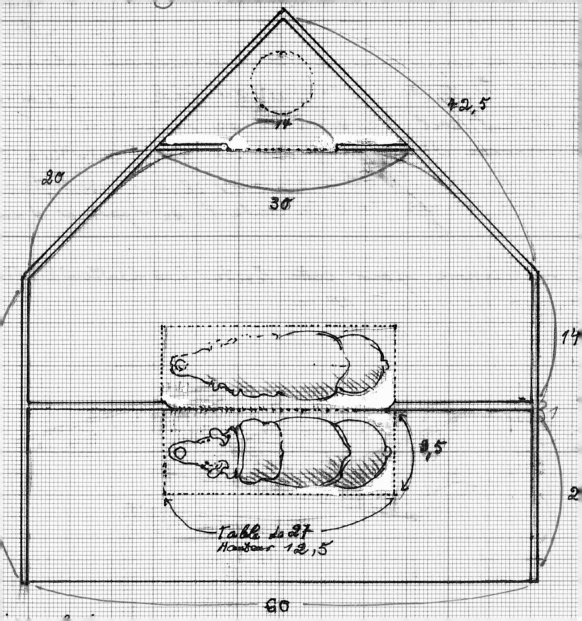

42,5

20

30

14

17

1

4,5

2

Table de 27
Hauteur 12,5

60

Rhinoceros-Homage to Eugene Ionesco, 2002

24 3/8 x 26 x 29 3/4 inches

Mixed Media Construction

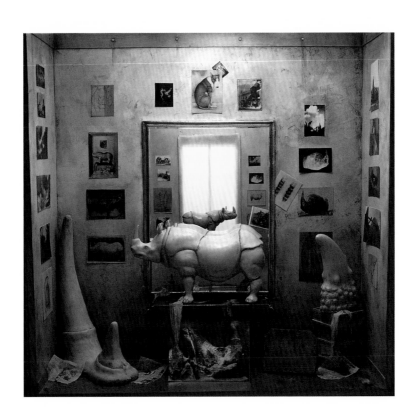

YVERDON HOTEL

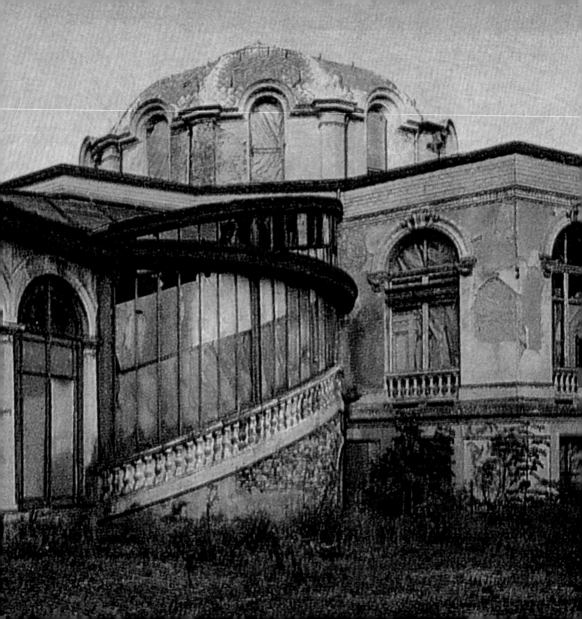

FIG 18

FIG 17

Yverdon Hotel, Genoa, Italy 2002

20 x 25 5/8 x 19 3/4 inches

Mixed Media Construction

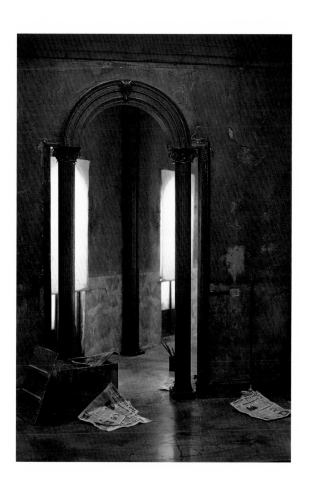

LIBRARY

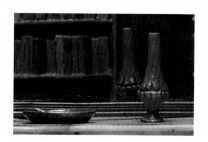

FIG 19

FIG 20

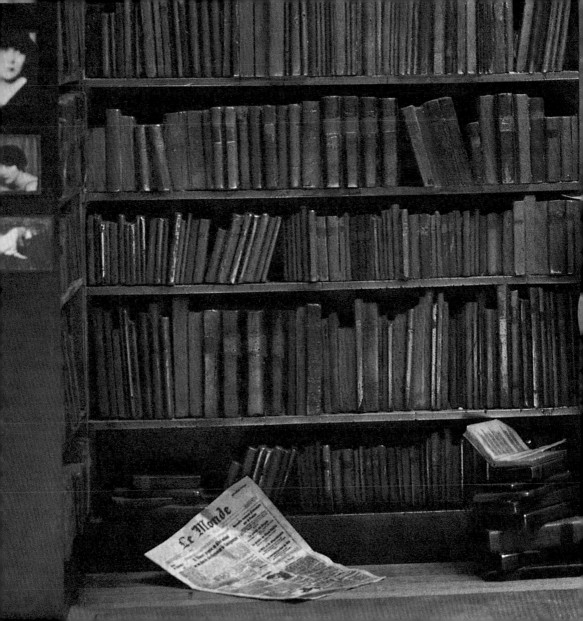

Library—Homage to Marcel Proust, 2002

25 7/8 x 15 3/4 x 20 inches

Mixed Media Construction

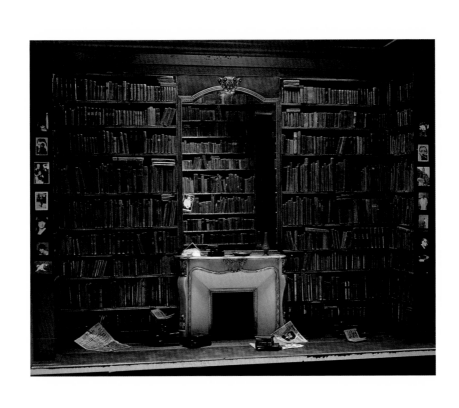

THE BIG STORAGE ROOM

En fait il s'agit de la réplique de "la remise d'un sculpteur I°" (FIAC) en plus profond et peu plus vaste.

hauteur 55 (intérieur)
PLUS vide (éclairage) ⟶

voir découpe du
plafond feuille Q II.

10(

Châssis à clé, deux plissés rideaux écrus, une étagère au mur central et trois table, deux colonnes et divers sculptures: les têtes issues de bloc, détail Freud (Sue), nez, grande et petites oreilles.... et coetera ...
Pas de plâtre (inversés.)

FIG 22

FIG 21

The Big Storage Room, 2000-2002

25 x 12 5/8 x 28 inches

Mixed Media Construction

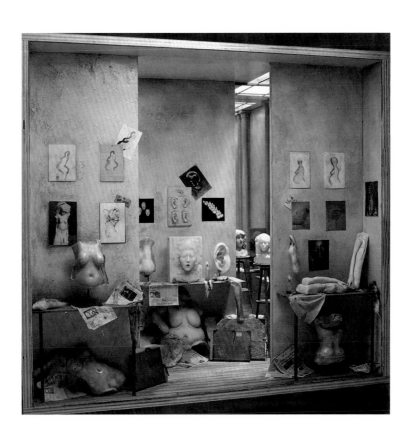

SIGMUND FREUD'S STUDY

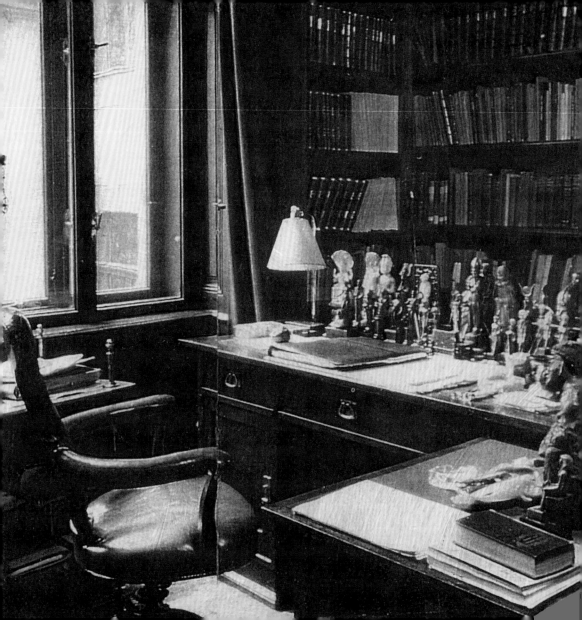

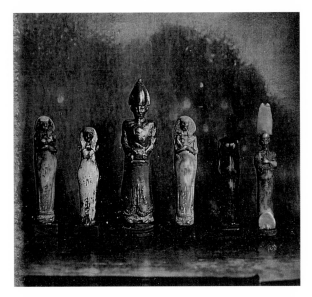

FIG 24

FIG 23

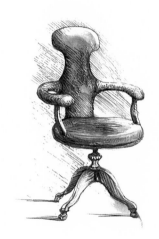

FIG 25

FIG 26

Le fauteuil de Sigmund Freud (étude technique).

fauteuil dessiné pour Freud par l'architecte Félix Augenfeld.

matière : cuir doré chargé d'une lourde patine

La couleur de la résine servant de base → grise verdâtre

à visser

Les éléments composant
l'assise doivent être tirés
ou résine chargée de poudre
de bronze, dans la proportion
de 75/100.

Sigmund Freud's Study, 2002

28 3/8 x 21 1/4 x 22 3/8 inches

Mixed Media Construction

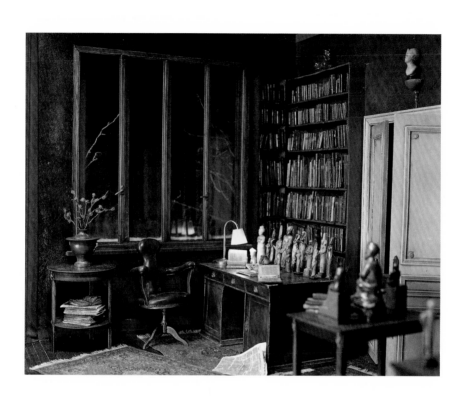

Forum Gallery

745 Fifth Avenue at 57th Street, New York, New York 10151

Telephone 212-355-4545, Facsimile 212-355-4547

www.forumgallery.com

Sponsored in part by Cunard Lines

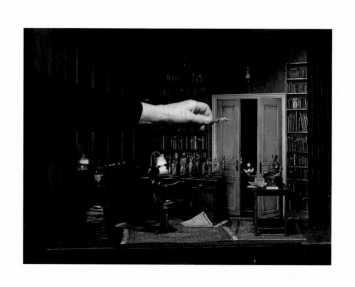